HUNG, DRAWN AND EXECUTED

All rights reserved. With the exception of quoting brief passages for the purposes of review, no part of this publication may be reproduced, stored in a retrieval system, or transmitted in any way or by any means, electronic, mechanical, photocopying, recording or otherwise, without the prior written permission of Korero Press Ltd. The information in this book is true and complete to the best of our knowledge. This publication has been prepared solely by The Publisher. We recognise that some words and designations mentioned herein are the property of the trademark holder. We use them for identification purposes only. This is not an official publication. Every effort has been made to ensure that credits accurately comply with information supplied. All rights reserved.

This book is dedicated to the countless horror fans who have supported my work and helped it evolve.

Korero Press Ltd,
157 Mornington Road, London, E11 3DT, UK
www.koreropress.com

First published in 2019 © Korero Press Ltd.
ISBN-13: 9781912740062

A CIP catalogue record for this book is available from the British Library.
Printed in China

HUNG, DRAWN AND EXECUTED

— THE HORROR ART OF GRAHAM HUMPHREYS —

KORERO PRESS

CONTENTS

Foreword by Dacre Stoker 7

Introduction 8

Foreword by Victoria Price 22

Book Covers 23

DVDs and Blu-rays 35

Film Posters 81

Miscellaneous 99

Posters 111

Private Commissions 139

Record Covers 151

Credits/Acknowledgements 173

FOREWORD

The legacy of horror would not be the same without the figure of Count Dracula, as potent a name as Frankenstein. When my great-grand uncle Bram Stoker wrote *Dracula*, he gifted the world a monster that is still evolving more than 100 years later. Likewise, the horror film has evolved immeasurably since F.W. Murnau's 1922 *Nosferatu*, yet the Count Dracula character persists. As cinema evolved, so did the horror film poster – and while most contemporary posters are digital compositions, the painted image can still find its place among the sanitized, Photoshop ubiquity.

The work featured in this book is a testament to a tradition as old as Count Dracula himself: from stained-glass windows to theatre posters, book covers to cinema posters, these are images which sell a theme and deliver a promise. Beyond the photograph and written word, a painted image can convey horror through colour and composition; it can mask the cracks and elevate the product – even becoming the product itself. When the sculptor Bryan Moore launched his campaign for the installation of a bronze bust to honour Bram Stoker's literary achievements, it was a painted image that became the face of the campaign. When I was asked to appear as a guest at the "Tomorrow's Ghosts Festival" in Whitby, Yorkshire, alongside four of Hammer Horror's best-known actresses, it was a painted poster that served the promotion, appearing on T-shirts and banners. These images were not simple exercises in nostalgia, but a contemporary exploration of a timeless primal response, feasting on the blood of the past to nourish the new. Graham Humphreys's art is both relevant and beautiful, and I am proud to have two of his works framed prominently in my home.

Dacre Stoker, great-grandnephew of Bram Stoker

FAR LEFT: *Bela Lugosi as Count Dracula*. College artwork, created as a portfolio piece, 1979.

INTRODUCTION

In 2015, I agreed to participate in a British TV show called *Four Rooms* in which invited guests bring items of perceived value to sell to one of four guest dealers (one in each of the titular four rooms), in the hope of negotiating a mutually beneficial deal. My plan was to fund the publication of a volume of my work and a supporting exhibition. I'd calculated the required sums and submitted two paintings I thought might attract the necessary finance: my illustrations for the UK theatrical distribution of the films *A Nightmare On Elm Street* and *Evil Dead II*. Failing to secure a deal wouldn't be a problem, I figured: I'd simply refuse to sell for less and walk away with the two paintings, none the poorer.

On the day of filming, one of the four dealers agreed that his publishing company would produce the book of my work, and his gallery would host the exhibition: in exchange for the two paintings and a token payment. The book, *Drawing Blood: 30 Years of Horror Art,* was published 18 months later, and an exhibition at the Proud Gallery in London's Camden Town marked the occasion. The deal wasn't without issues, however, and the price point made the book a difficult buy for many.

Since 2015, I've produced a new body of work, which is the focus of this volume. However, I've also included art that appeared in *Drawing Blood*; by repeating some of the images, I can provide context for the new work and allow those who found the first volume beyond their reach, a chance to own some of those original pages.

LEFT: Photograph of the original painting of *A Nightmare on Elm Street* (1984). From the artist's archive; all rights reserved.

INTRODUCTION • 9

ABOVE: The cover for *Drawing Blood: 30 Years of Horror Art* (2015) was inspired by recent refurbishments on the London Underground. At Piccadilly Circus station I could see some platform cladding had been removed to be replaced. The opening revealed older wall space that had once provided the surface for numerous posters – a texture of many torn-away layers revealing further posters beneath. This suited my homage to both the film poster as a format and the tear-it-up punk rock graphics that filled my college years. © 2015 Graham Humphreys Ltd.

For those unfamiliar with my work, it's worth making a brief introduction. I was born in Bristol in 1960, the family later moving to Wiltshire. My career as a freelance illustrator began when I left Salisbury College of Art in August 1980 and moved to London; the relocation was necessary because, in this era before the internet and email, most introductions would be made face to face during my search for work. If I received a commission, I'd need to be on hand to be briefed in person, then deliver any initial roughs and the final art. During this early period I arranged to meet key staff at Palace Pictures, a fledgeling film distribution company, and within weeks I was asked to produce my career-defining poster for Sam Raimi's 1981 film *The Evil Dead*. Produced purely for the UK market, the campaign struck a chord that propelled the film to great success, both theatrically and simultaneously on VHS (a marketing first). This, in turn, led to the UK poster for *A Nightmare On Elm Street*, the second of the two posters that consolidated my future in genre work. Being a freelance illustrator wasn't an easy option in the 1980s, and it's even less so today; however, my diploma in graphic design gave me the skills to survive the leaner times, allowing me to produce a diverse range of work and earn a basic living. I lived from month to month (even for one year taking the role of part-time lecturer) but persisted in my work. If I have to identify a reason for the continuous flow of commissioned work I enjoyed, it's most likely because I felt confident in my own particular style and approach, even after the numerous rejections and the occasional setback. I knew it was essential to avoid the stylistic traps that curtailed the freelance careers of many contemporaries. As a genre fan myself, I hoped I could identify the elements that might appeal to horror fans. My "style" was born out of two things: the films, posters and horror literature that enthralled me as a child and the music of my formative years – punk rock. It's no coincidence that the two have often collided during my working career, both in record sleeves and magazine illustration and within film production. Although I'd been taught how essential it is to be receptive to new influences, I know my work will always stand astride two rocks – punk and horror.

Let me briefly explain how my work is produced. Despite the versatile resources offered by digital technology, all my paintings are created in the tradition of paint on paper. Although I've tried experimenting, Winsor & Newton's Designers Gouache is my chosen medium; it provides a versatile range of applications, from washes to dry brush work. Unlike acrylic, the colours can be reconstituted with water, rather than drying to a plastic skin. I use a "not" surface watercolour paper, which has a "bite" that allows a good range of textures.

Over the years, I've found that a basic range of eight colours provides all my needs. I use Prussian Blue and Alizarin Crimson for the darkest hues, as I try not to use any black, unless absolutely necessary. If I do use

black it's Ivory Black. Prussian Blue and Brilliant Yellow give me a full range of green. Ultramarine is suitable for certain blues, and mixes well with Alizarin Crimson for a range of purples. Oranges use Marigold Yellow mixed with Brilliant Yellow and Alizarin Crimson. The opaque lighter colours are mixed using Permanent White. I also keep Flame Red for very sparing use. Completed work is scanned for digital delivery, while I retain the originals.

Artists are often asked: "Who or what are your influences?" For me, there's no simple answer because influence is drawn from all experiences of life. That said, *Doctor Who, Lost In Space, Batman, The Munsters* and *The Addams Family* all featured in the TV diet that fed my childhood imagination. Then there's the writing of Edgar Allan Poe and H.P. Lovecraft, the novels and short stories that inspired the Universal Monsters (resurfacing in Hammer Horror). And, of course, horror films themselves.

My stylistic inspiration includes the US poster artists Drew Struzan, Richard Amsel, J.C. Leyendecker and Bob Peak. In the UK, Tom Chantrell illustrated many posters that I saw promoting Hammer Horror. Work from earlier periods also influenced me, in particular the prints and posters of Jules Cheret, Alphonse Mucha and Toulouse Lautrec. My poster for *A Nightmare On Elm Street* owes a great debt to Jules Cheret. As a child, I experimented with 3D work, using cardboard, tissue paper, modelling clay, wire… In fact, whatever was to hand. I crafted horror-themed small figures, *Doctor Who* monsters and exploding airships. I even created ships in bottles. I made many crude attempts at the

ABOVE: Photograph of the original painting of *The Evil Dead* (1981). From the artist's archive; all rights reserved.

INTRODUCTION • 11

illusion of dimension, either with simple flat layers or viewing boxes (an interest that resurfaced when I designed a 3D album cover for The Cramps in 1983).

In 1970, I spotted the first of the Aurora "glows in the dark" monster model kits, and the depiction of these creatures in lurid colours on the box really caught my attention. Stacked in the local department store among the teddy bears and Airfix aircraft, these were startling abberations. The Dracula and Hunchback of Notre Dame artworks are still imprinted in the back of my mind and form the basis of many of my colour palettes.

For many kids of my generation, it's impossible to overestimate the influence of Denis Gifford's *A Pictorial Guide to Horror Movies* (1973), whose cover was as exciting as the Aurora monster boxes. The book is a perfect introduction to a whole world of horror films, lavishly illustrated with stills that intrigue and terrify in equal measure. I still have my copy.

Enrolling at art college in 1976 challenged my naivety. I began to learn and respect the drawing skills that would prove so useful in my career. Simultaneously, punk rock changed my personality, culturally opening up possibilities and blasting away adopted attitudes. Art history lectures peeled back the layers of ignorance and enlightened my mind. With a clear vision and a new hunger for visual stimulus, I soaked up everything from the fantasy art of Roger Dean and Bruce Pennington to holography and arthouse cinema, soundtrack music and politics. With the guidance of visiting lecturers (themselves at the threshold of a cultural shift), I found the tools to shape how my work would eventually look. I'd already experimented with poster paint

LEFT TOP: My attempt to re-create "The Giant Robot" seen in a Tom Baker-era *Doctor Who* story. Using stills from a magazine as my reference, the entire figure was constructed from cardboard. Photograph from the artist's archive, c.1974; all rights reserved.

LEFT: The Dracula image on the front of the Aurora model kit box that proved so influential in my later work. The artwork had been altered to create a "glow" effect, to differentiate it from a previous edition, and it was this adulterated version that had a massive impact on my impressionable young mind. The artwork was painted by US artist James Bama (c.1964), best known for his Western paintings. Photograph from the artist's archive; all rights reserved; box c.1970.

12 • INTRODUCTION

before college and found that the juxtaposition of two particular colours always had an uneasy, almost sinister, effect, the visual power of which fascinated me. Years later, I was introduced to Joris-Karl Huysmans' book *À rebours (Against Nature)* while working on an album cover for the band The Lords Of The New Church. A particular song had reminded the project's art director of a passage in the book and she suggested I read it for further inspiration. I was delighted to find a description of these same two colours, identified by the author as conjuring that unnerving and unnatural effect. I use these colours in my work as often as possible.

On the following pages, 14–21, is a step-by-step breakdown of how I painted the cover for the book *The Boris Karloff Compendium* (2019).

ABOVE: *Scared Stiff* (1987). This artwork was painted in the 1980s for a client describing themselves as "a headhunter", a middle man – I didn't deal directly with the film's distributor. However, it was clear that my brief was to keep it "horror" and thereafter do what I felt was right. I took the elements I thought best represented what I'd enjoyed personally, which fortunately found favour: the painting was delivered, never to be returned. When Arrow Video recently licensed the artwork from me (a limited edition slipcase) for a reissue of the film, my only origination was a video trade ad from the 1980s that I'd retained for my files. I had to scan and retouch this (removing some text): it wasn't ideal, but I had no other option. © Arrow Video 2019

ABOVE LEFT: *The Stuff* (2017). A commission for the UK quad and VHS releases of a 1985 horror comedy film; Arrow reprinted the image as part of the package for their 2017 reissue. I recall the original brief was to illustrate a head with "the stuff" oozing out of it. No particular character was required, so I used my reflection for the necessary facial detail. Oddly, the original VHS image is fondly remembered, with at least one person (with whom I have subsequently worked) claiming it was their favourite VHS cover from that era. © 1985 New World Pictures. All rights reserved.

1. With every commission, the first step is accepting and understanding the brief: in this instance, the client supplied me with a list of Boris Karloff's best-known roles for depiction and gave me access to a number of photographs of the actor. My initial job was to select the portraits that would fulfil the brief, while providing the best possible reference.

2. After making a selection of suitable photographs, I adjusted each one in Photoshop, balancing the tonal values. The photos were then printed on A3 sheets of paper and placed on a lightbox so I could trace each portrait in pencil. A sketched image ensures that the quality of the photograph doesn't influence the client's expectations of how the final painting will appear.

3. Using the scanned sketches I composed my layout, paying attention to the impact and visual harmony. The elements are moved or resized in Photoshop, according to what feels most effective. I have to be aware of eyelines and the illusion of perspective. Placement is crucial in making a harmonious composition that has some vibrancy.

4. Once the client had approved the composite sketch, I reintroduced the original photographs over the digital layout, placing them precisely over the pencil outlines. In this way, the layout remains exactly as approved, and it also gives the client the opportunity to begin any layout work of their own, knowing that the illustration will fit as planned into my layout. Extra bleed is always added when possible.

5. The photographic layout was then printed at the size my painting was to be made. This allowed me to trace directly onto the watercolour paper of a light enough weight not to bar the backlit image. Again, using the lightbox, I was careful to trace as much precise detail as possible in order to ensure the likeness didn't deviate from the original photograph.

6. The traced image was taped to a wooden board with masking tape. This ensures the paper is held in position but can be removed at the end of the painting process without risk of tearing the final art. It also ensures that when the initial wash is added and the paper buckles, it will return to its flat state once dry.

7. Before colour was applied, I brushed water over the surface, which made the paper receptive to the paint. I was careful to keep this "blank" wash within the confines of the taped paper. Once the surface was wet all over I didn't add more water as the paint would simply run off the watery flood. The process is rapid because the water will dry swiftly (the paper isn't soaked).

8. I then quickly mixed the chosen base pigments. Certain colours are better than others for this process. Some pigments tend to have an opaqueness that simply blots out the pencil image. The balance requires strong pigments that will dry, allowing the drawing to still appear beneath. I use this process to establish an underlying colour theme, and some of the wash will remain as part of the final art.

INTRODUCTION: STEP-BY-STEP • 15

9. In order to add interest, and often to darken the edges as well, the pigment is applied using a large brush to splash colour on the initial wash. This is all about timing, as the colours need to sit where I splash them, with some bleeding outwards, but not so much that it just becomes an area of single colour. The forcefulness of the application has a bearing on the final effect.

10. Here, I'm dipping my fingers into water and flicking drops onto the surface. Again, this is a process that has to be rapid yet perfectly timed for the desired effect. If the surface is still very wet, the clear water is swallowed up by the existing pigment. Too dry and it has no impact. The effect creates a marbling, not always predictable but integral nonetheless.

11. The surface needs to dry without being disturbed. It's a mistake to try and hasten the process: a hairdryer would simply blow the wet paint across the paper. The wet layering needs to settle without movement. By keeping the board still and allowing room temperature to do the job, the resulting textures are more pronounced and retain their spontaneity.

12. The dried surface reveals all the minute runs and bleeds that the pigments have made. Certain colours can form more interesting effects.

16 • INTRODUCTION: STEP-BY-STEP

13. The surface has a transparency that reveals the pencil drawing and provides a better surface for painting than the raw paper. In addition, it helps consolidate the drawn elements and provides a coherent visual landscape upon which to build the illustration.

14. Being right-handed, it's practical for me to work from top left to bottom right; this also means less disturbance on the painted surface. A piece of paper was used to protect the paper beneath the hand, as natural skin oils can build up resistance to the water-based pigment. I usually begin by defining the darkest areas, being careful to follow the pencil guide beneath.

15. This stage begins the illusion of a sculpted image, adding dimension. It also starts to unify the composition — there's a common feel to the linework and textures, whereas the photographs often vary in quality and look. This is really the creation of a monochrome version, where the blocks of light and dark form the base from which the colours can be built.

16. During this process, I refer to the wash beneath to suggest colour difference. Here, the top two portraits are picked out with a dark, cold blue; below there's a slight addition of orange and dark red to give the blue some warmth. But the base wash had already determined a softer crimson outline for the next portraits. The colour palette is becoming more apparent.

INTRODUCTION: STEP-BY-STEP • 17

17. Here, the "blocking" stage is complete. At this point, I had a framework in which to build more definition and colour. The detail retained from the pencil stage had now been worked over and was no longer useful. Although I always have a basic idea of how the finished art will look, this stage really begins to shape the final look, colour and contrast.

18. This is where I rely on my years of experience to guide my hand. The first wash usually acts as a mid-tone for the image. Having defined the shadows and basic sculpting, this is where the build-up of light and colour gives the illustration its "life". This is also where referring back to the photographic reference is once more crucial in maintaining the likeness in the portrait.

19. Although the base wash is a guide to the overall colour scheme, sometimes I'll work against it to create contrast and dimension. The flesh colours on the second portrait have completely lifted the image above the first. There was still enough of the wash below coming through to ensure it wasn't entirely jarring to the eye. The brush technique is almost pencil like: the strokes are in fact multiple lines.

20. The progress was swift from this point on. Each previous section helped me to make decisions as I moved across the composition. Occasionally I'll make a random choice, unplanned. This particular commission had only black and white reference, and therefore the colours were mine to choose. There's a flow of warm, rich oranges that stop abruptly at the lower portrait; this adds to the illusion of dimension.

21. With the illustration virtually complete, I went back over the various sections, making adjustments, adding detail and reworking where necessary. A useful tool for this stage has always been a handheld mirror. By checking the reflection, it's possible to see the composition as if for the first time – it's astonishing what's revealed. In fact, I continuously use the mirror throughout the entire process.

22. Before the masking tape was removed, it was possible to see that the addition of outlines had helped pick out the various elements. Although it can create the appearance of a series of cut-outs if not used with subtlety, I've found this to be a very useful technique for defining the negative spaces, whose shapes need to be as harmonious as the images themselves. The colour and application of the outlines have to be very considered.

23. A further technique I've learned to use (although sparingly), is a fine splatter effect. It can be useful in resolving awkward transitions within the art. The colours have to be carefully chosen and the effect localised, so as not to intrude on the detail (bits of torn paper create useful masks); a careful brush and paint/water mix also determine the effect. It's these final touches that breathe life into the painting.

24. The art was now ready to be scanned. I use a convenient A4 desktop scanne for this; however, this means scanning in sections. In this instance, I made six separate scans, allowing for plenty of overlap. I always add weight to the top of the closed scanner lid (the white plate I use for mixing paint does a good job), which ensures any undulations in the paper are flattened to the glass for the best possible results.

25. The scans are never perfectly colour matched to the actual painting, but I know these can be adjusted using software. I just need to ensure that the whole image has been scanned as parallel as possible.

26. Here, two scans are layered over each other; there's plenty of overlap so that when one scan sits over the other, I can erase sections at the join without risking an obvious straight line. The finished composite image is then colour balanced to match the original painting. I know that the screen I use provides a good representation that translates to print fairly accurately.

27. Once the final file had been converted to print colours (CMYK) and additional colour balance made, I needed to check if extra bleed was required. (I tend to paint only the areas required, knowing that I can add to the edges later.) The client had provided a guide, using my original sketch composition to determine the position of the title and required image area.

28. With extra bleed added by sampling and stretching existing edges and careful image editing, the final file was ready to be delivered (once approved by the client). Using freely available large file transfer software, the image was delivered ready to be added to the final book cover layout. As always, the original art was carefully rolled for storage (or sale).

20 • INTRODUCTION: STEP-BY-STEP

FOREWORD

Growing up, I had no idea that I was the daughter of the King of Horror because the dad I saw at home and spent time with on the road was first and foremost an art lover, art historian, art collector and arts advocate. Vincent Price had studied art history at Yale and the Courtauld Institute of the University of London before he became an actor – and the visual arts remained his greatest passion.

My dad delighted in teaching me, his only daughter, about the art he loved so much: we found such great joy exploring museums together and looking deeply at his art collection. When I grew up, I followed in his footsteps and became an art historian and art collector. When he was dying, we spent a year working on a book together about his life in the visual arts. After his death, I went on to own one of the top art galleries in the world – and to this day, the visual arts remain one of my own greatest passions.

This is why it has been such a joy and honour to discover the work of Graham Humphreys – whose superb painted images and illustrations are infused with his lifelong passion for the horror genre. I have watched the sheer delight that Humphreys' fans experience when they see the horror icons they love elevated to subjects worthy of being enshrined in art. And as the daughter of one of these icons, I have been so grateful to Graham for the ways in which he has carried my father's legacy forward to new generations of fans.

My dad once said to me: "Art is our highest expression and must not be relegated to the isolation (if not the total oblivion) that unthinking men and women would banish it to – using the cliches that art can be created out of ignorance and without encouragement. Art needs every encouragement, for its value tends to escape most of us after we have been educated out of the original acceptance of it as a prime fact of life – when we were young and unspoiled by ignorance."

I am so delighted that this book will encourage more people to discover and enjoy the extraordinary art of Graham Humphreys – and I know it will bring them the joy it always brings to me to experience the incredible quality and passion of his life's work!

Victoria Price, author of *Vincent Price: A Daughter's Biography*
and *The Way of Being Lost: A Road Trip to My Truest Self.*

BOOK COVERS

At the beginning of my professional career, book covers were among my first commissions. In fact, my very first professional job was a book cover. Many of those early titles were commissioned for educational publishing, and I have a large body of work that fulfilled the educational remit. For this volume, I've concentrated on the most recent work with a genre bias. Most of these book covers were commissioned for specialist editions.

LEFT: *Beware The Moon* (2017). Paul Davis's book about the making of the 1981 cult horror comedy film *An American Werewolf In London* required a particular image on the cover: the two backpackers in the mist, a full moon and a shadow resembling the werewolf. As there was only one good reference image for the two actors that I could reasonably use, the challenge was to make the angle work with the shadow and the position of the full moon. Although I'm not convinced the cover art is entirely successful, the book sold well and had a second print run. I added the werewolf eyes in my original painting, as I felt there should be more information on the cover; however, at the request of the author, these were removed (using Photoshop) – although they appear on the same image reproduced inside.

RIGHT: *Lost In The Shadows: The Story Of The Lost Boys* (2017). The cover for this book about the 1987 teen vampire thriller *The Lost Boys* came with some art direction from the author, Paul Davis. The artwork had to feature Keifer Sutherland's character at the top centre, alongside the two other lead actors. Aiming to re-create the layout of the original UK quad poster, I chose to ramp up the vampiric elements and deliver a full-fanged image that depicts the entire "roost".

THE LOST BOYS

Sleep all day. Party all night. Never grow old. Never die. It's fun to be a vampire.

'Lost In The Shadows: The Story Of The Lost Boys' available from Cult Screenings UK Ltd. Artwork: Graham Humphreys

LEFT: *Cult Cinema: An Arrow Video Companion* (2016). This first book publication from Arrow Video is a collection of commissioned writing by film genre experts and critics. The cover needed to represent the range of releases and include some specific portraits of genre directors. I was given a list of suggestions and sourced the images I felt best conveyed the range, though the quality of reference material dictated the options for the prominence of certain portraits.

BOOK COVERS • 27

MONSTERS TO DIE FOR!

They live!

FAR LEFT: *A Century of Horror*: (*Monsters To Die For! They live!*) (2018). With the seminal Denis Gifford book *A Pictorial History of Horror Movies* providing a touchstone for many of my generation (and our entry into the world of horror movies) this painting is a homage to Tom Chantrell's memorable cover. Armed with a shortlist of characters to represent, I was able to highlight my preferences; the only addition not on my list was the Zenomorph from *Alien*, which was added for a more contemporary reference.

LEFT: *Spotlight on Horror*: (*Monsters To Die For! They bite!*) (2019). In this second volume, I used my own shortlist of subjects from the publisher's own much longer wish list. The only stipulation this time was the addition of the film *Jaws*. The colour palette is more akin to the Denis Gifford book, but I've also attempted to redress the gender balance by including more female characters.

BOOK COVERS • 29

ABOVE: *Undead Uprising* (2016). Rather than a history of zombies that one might expect, the book is a serious examination of the zombie/Vodou phenomenon, which is best understood through colonial racism and the internal and external interests that exploited the supernatural beliefs of Haiti's people. My brief ensured that while I was representing some of the more lurid aspects of zombie film and ritual, I also incorporated an image of "Papa Doc" Duvalier, the infamous president of Haiti, and Baron Samedi, the august Vodou spirit.

RIGHT: *245 Trioxin – The Story Of The Return Of The Living Dead* (2016). Most of this cover was painted while I was attending the Aberystwyth "Abbatoir" film festival in Wales. Although I was primarily at the event to participate in a talk, I also had a table where I could sell prints. However, given that most of the event was film screenings, I had plenty of time for painting without distraction. It always seemed like a good idea to be seen painting an actual job – a process most people don't get to see – but the reality of distractions and poor light means I no longer find it practical to attempt. This artwork is the third painted for the same film. This time I was able to introduce characters I'd not represented previously, and the tone is less cartoony than before.

DEFYING
JORDAN'S STORY

32 • BOOK COVERS

LEFT: *Defying Gravity – Jordan's Story* (2019). A key figure in the UK's punk rock scene, Jordan was, alongside Johnny Rotten, the face of punk to many of us at the time. With a look that was totally alien in drab mid-1970s Britain, Jordan provided a conduit for a part of the generation seeking a new form of expression. For the cover art, a meeting was arranged with Jordan, the book's co-author (Cathi Unsworth) and the publishers; it was intended as a formal introduction during which an approach would be discussed, but when Jordan produced a bottle of champagne, it became more of a party. I requested a shortlist of essential elements to include on the cover. Among these were Jordan's involvement with Malcolm McLaren and Vivienne Westwood's shop in London's King's Road – a pivotal meeting place that spawned the Sex Pistols – and also her love of *Star Trek* and Burmese cats. Overt references to *Star Trek* would have been a legal impossibility, but I included a "Vulcan" salute and chose colours to match the look of the show's first series. It was a thrill for me to acknowledge Jordan, a woman who'd had such a profound influence on my work.

BOOK COVERS • 33

LEFT: *A Celebration of Vincent Price* (2019). This book had a very limited budget, so rather than attempt the approach of the "Karloff Compendium", we thought that a single portrait encapsulating Vincent's character would suffice. The photographic reference was particularly good and the expression just right. I had only to consider the colours that would best complement the portrait, and for those, my choice was immediate.

DVDS AND BLU-RAYS

It's been a privilege to have participated in the growth of home entertainment through my work on VHS covers. Although the death knell may have sounded for physical media, many collectors continue to enjoy the tangible box and colourful artwork that fills shelves in the same way as cherished books; the collectors market is still thriving. Where VHS was once the portal for little-seen movies and cult curios, DVD and Blu-ray ushered in a new era of enhanced presentation and special edition packaging. What the future holds is under debate, but the appetite for movie-related art is still being satisfied.

LEFT: *Bombshell Bloodbath* (2014). I was approached by the filmmaker to design an image for the DVD release of this low-budget but enjoyable 2014 homage to the genre, which has more than a nod to 1985's horror comedy *Re-Animator*. I recall creating this artwork whilst attending a convention as a guest of Arrow Video, literally painting at the company's table during the event – partly by way of a demonstration of illustrating skills, but also because I had a deadline to meet! The lighting at Birmingham's National Exhibition Centre was very yellow, so I wasn't entirely sure what balance of colour I was mixing. It seemed to work though.

RIGHT: *Attack of the Adult Babies* (2018). This was commissioned as a limited edition slipcase. I'd already seen the film at the London Frightfest in 2017, and had met director Dominic Brunt through his role in the film *Inbred*. I enjoyed the film's satire on class and the establishment, so I was thrilled to be asked to render my own version of a poster. From the outset, I knew I was going to use "baby" colours!

THE CITY OF THE DEAD

LEFT: *Asylum* (2019). The horror anthology films made by Amicus Productions in the '60s and '70s featured many of the stars of the company's rival, Hammer. The films' portmanteau format allowed a breadth of talent to appear within one feature and elevated cameos to lead roles. When I was asked to paint limited edition box covers for two of these films, including 1960's *Asylum*, my options were to capture the essence of the wraparound story or concentrate on key portraiture. I opted for the latter, simply because of the fantastic range of British character actors, many of whom are now departed. The result is in part a memento mori – I wanted to honour these titans of the British film industry. The colour palette is intended to convey the deathly pallor often associated with the aggressive marketing of horror subjects.

FAR LEFT: *The City of the Dead*. (2016). It was a thrill to be given this 1960 film (whose US title is *Horror Hotel*). It stars Christopher Lee in an early role in which he's obliged to deliver lines in a not entirely convincing American accent. However, the set-bound film manages to conjure up plenty of monochrome atmosphere, which is represented in the simple colour theme.

DVDS AND BLU-RAYS • 39

LEFT: *Mark of the Devil* (2014). This great German film (released in 1970) about religious persecution and superstition in 1770s Austria, has a great cast, lashings of character – and lashings! It makes an excellent companion piece to 1968's *The Witchfinder General*. I knew I wanted a "good, bad and ugly" feel to the sleeve: Udo Kier (as a witch hunter) looking just as pretty as the girl; plus some theatrical villainy, for which Reggie Nalder certainly fits the bill.

RIGHT: *The House That Dripped Blood* (2019). Ingrid Pitt, reprising her "Countess Dracula" role, and one of my favourite Doctor Whos, Jon Pertwee, join two of Hammer's biggest stars, Peter Cushing and Christopher Lee, in this 1971 British horror anthology – the second of my Amicus Blu-ray box covers. I loved Pertwee's bizarre vampire characterisation: Doctor Who with fangs! There's also an overt horror reference on the "To Let" sign, which appears several times throughout the film, elevating the vampire sequence with a reference to Bram Stoker.

DVDS AND BLU-RAYS • 41

ABOVE: *The Man of A Thousand Faces* (2019). A film I've yet to see but have always known about, this is a 1957 biopic of silent-film actor Lon Chaney – portrayed by James Cagney – who was known for his extraordinary makeup transformations. My brief for this Blu-ray required no more than a selection of portraits that celebrated some of Chaney's most famous characterizations – or rather, this film's pale imitations of them. I worked from some supplied stills, and by representing the portraits in paint, I was able to conceal the obvious rubber prosthetics!

LEFT: *The Fall of the House of Usher* (2013). This is one of the films that left a lasting impression on me in my formative years. For the cover of the Blu-ray of this 1960 classic of the horror genre, I wanted to capture the essence of the Corman-Poe-Price combination, using the expressive features of Vincent and a colour palette that seemed of its time. The result is a full Gothic celebration of blazing colour.

ABOVE: *Phantasm* (2017). I'm always wary of working on a "classic" of the genre – such as this 1979 horror/sci-fi film – because I can only disappoint. In this instance I had some art direction from the client, so I felt absolved of my choice of images!

ABOVE: *Phantasm II* (2017). Again, client direction shaped the image. I had only to ensure that the box art for this 1988 title retained the feel of the first film; it was the same with the sequels: *Phantasm III* and *Phantasm IV*.

RIGHT: *Phantasm III* (2017). The cover for the third film in the franchise (1994) was art directed by the client, requiring a variety of the killing machines and character choices and a further shift in the colour palette.

LEFT: *Nikkatsu Diamond Guys Vols 1 & 2* (2016). This commission required me to include elements from three 1960s films produced by Japan's oldest studio. I looked at Asian posters for inspiration and tried to give it a retro look, including in the use of colour. My reference was supplied as a series of monochrome images; without having seen the films, I simply picked the images I found the most appealing.

RIGHT: *El Topo* (2007). During the decade I freelanced for Tartan Films and Video, there was only one project – this 1970 Acid Western – that required an illustration. Intended as the cover for a DVD release, this art was only used as a promotional insert for a magazine. However, when I met the film's director, Alexandro Jodowrosky, at a screening of *El Topo* at the National Film Theatre in London, he told me that it was his favourite image for his film. No greater praise could I have hoped for.

WILLARD BEN

ABOVE: *Willard/Ben* (2017). Rather than merge the themes of these two horror films (1971's *Willard* and its 1972 sequel, *Ben*), I was asked to create two distinctly different "posters". To avoid an obvious split, I linked the two with the rat eating its way out of the image. Nevertheless, it was a good excuse to paint Ernest Borgnine and Elsa Lanchester!

RIGHT: *Worst Fears* (2016). Another horror anthology requiring a linking image, thankfully supplied by some newly shot photographs of David McGillivray, the writer and producer of these seven short films. Elements from each of the seven short stories were required for the cover.

LEFT: *Evil Ed* (2017). With no specific brief, I watched the 1995 film and built my image around the central character: a murderous film editor. The film is something of a classic in Sweden, where it was made; I received positive feedback from the makers, via a Swedish friend.

RIGHT: *Dr. Giggles* (2017). My brief for this 1992 slasher film required a large portrait of "Dr. Giggles", a deranged, vengeful man who poses as a surgeon, with additional elements that I could choose. I added the gloved hand and syringe to link the "doctor" to his victims. This reproduction of the art is in the colours I initially chose. The client wasn't so happy with my choice, so I used Photoshop to shift the colours along the spectrum to create more greens – and that made him happy.

50 • DVDS AND BLU-RAYS

LEFT: *The Witches* (2017). Occasionally I'll be briefed for a job where my initial excitement centres on the title, only to find that the subject matter bears little, if any, relation to it. This is one such job. There are no witches in this rather odd 1967 anthology of unrelated films that feature the same lead actress, Silvana Mangano. Aside from one of the significant supporting actors (a young Clint Eastwood), Rome's Colosseum (which appears in one story) was the only additional element I required to signal that this is not a witch film! I had only to select the best central portrait of Mangano to deliver the job.

RIGHT: *Return to Nuke 'Em High Vol. 1.* (2014). It's probably fair to describe this 2013 comedy horror as typical of Troma Films' output. But I wanted to ensure that the girls were in charge on my layout. The rest of the cover was a pick of characters and effects that I felt best exploited the exploitation! My client requested that I add blood to the skeleton and replace the burning skull with the actor's actual face. This is the original version before the changes.

52 • DVDS AND BLU-RAYS

LEFT: *Inferno* (2013). I was giddy with excitement when I received this commission for the cover of possibly my favourite Dario Argento film, and I had to restrain myself from including every scene. There are definitely moments that are common to other campaigns for this 1980 supernatural horror film, but I felt the rats were underrated and decided to give them their moment. I liked the art deco elements in the set design and the intense colours, so I thought it essential to use these to add a visually rich, decadent feel.

RIGHT: *The Barn* (2017). This commission arrived through an unconventional means. A small private cinema club screened the movie, and afterwards audience members were interviewed on-camera; the films were then relayed to the director (based in the US) for possible inclusion in any Blu-ray extras. I'd enjoyed the film and when interviewed said that it would have been the sort of commission I'd relish. An email followed within a couple of days, inviting me to create some new art for a limited release. With so much imagery to choose from, this became one of the "busiest" compositions I'd attempted. After sending my sketched options, I was asked to make one further character inclusion – for which a donation to the fee was made by the crew (who knew I was already delivering more than usual).

54 • DVDS AND BLU-RAYS

THE BARN

HOWLING II

ABOVE: *Horror Express* (2018). An all-time favourite film of mine, this 1972 sci-fi horror has Christopher Lee, Peter Cushing, Telly Savalas, a train and plenty of graphic horror. It's a loose adaptation of John W. Campbell's 1938 novella *Who Goes There*, originally adapted as Howard Hawks' *The Thing from Another World* (1951), and then much later as John Carpenter's *The Thing* (1982). Apparently, the original setting was changed after the use of a prop train became available!

LEFT: *Howling II* (2016). While this 1985 sequel to 1981's *The Howling* isn't the greatest horror film, it has enough powerful and surprisingly gory imagery to dress the sleeve. And it also has Christopher Lee and the domineering Sybil Danning to give a damned good party.

DVDS AND BLU-RAYS • 57

ABOVE: *Shock Treatment* (2018). An option of two limited edition covers for the same 1981 film: a musical comedy that follows on from the *Rocky Horror Picture Show*. The characters were so strong it seemed futile to attempt much other than introduce the TV screen (a cut-out revealing the film's title on the sleeve beneath). The neon outlines were intended to convey the glitzy artifice of the TV show that features within the film. A single sleeve option brought all the characters into one layout. Additional elements were created for the limited editions, including some mix'n'match head and body cards.

LEFT: *Schlock* (2018). This was the relatively simple option among those I presented for the cover of this 1973 low-budget spoof of '50s horror movies by John Landis. However, it wasn't issued as the main cover, and functioned as a reverse option instead. A shame, as I'm rather fond of it.

LEFT: *Return of the Living Dead Part II* (2018). As this was my fourth cover for this 1988 zombie film, it was suggested I include some previously unrepresented characters. Inevitably, the famous "tarman" still dominates, but it was fun to play with a wider colour spectrum and new narrative elements. In my enthusiasm, I overloaded the image, so the building and car were removed to allow the title to fill a bigger space. This is my original, full version.

RIGHT: *Necronomicon* (2019). After re-watching this 1993 French/American anthology horror film (I'd seen it years earlier but had forgotten much of the imagery) I had a clear idea of the elements I wanted to use. The colours were an essential part of creating a festering, stagnant feel – something unwholesome. Yet there's quite a comic book feel to the image: possibly because I was trying to portray the fragmented, four-part film through unrelated moments, although the intention was to create a queasy kaleidoscopic view of the whole.

Necronomicon

ABOVE: *Hired to Kill* (2016). My brief suggested that I focus on actors George Kennedy and Oliver Reed… I was happy to oblige. With its preposterous premise and determination to please on all levels, this 1990 action film allowed me to explore the exploitation potential and add a jaunty angle.

RIGHT: *The Best of '80s Scream Queens* (2018). This cover was for a three-film box set that strongly featured US horror-movie actress Linnea Quigley, known as the "scream queen". I was asked to concentrate on the sexual nature of the set (or at least on Quigley's characters) but to add enough elements to signify the horror genre.

ABOVE: *The Count Yorga Collection* (2016). I recall seeing a Count Yorga film many years ago on late-night TV, perhaps even on an old black and white set. I knew these US vampire films had a cult following and was keen to see both the original (*Count Yorga, Vampire*, 1970) and the sequel (*The Return of Count Yorga*, 1971) for this double bill collection. I imagined Californian Hammer – in essence, what the films were trying to achieve. The image of actor Robert Quarry's vampire features said it all.

ABOVE: *Kill, Baby... Kill!* (2017). I wasn't sure where I should concentrate the focus for this acclaimed 1966 Italian Gothic horror film, but I decided to throw some random plot elements into the composition and aim for an atmospheric colour statement. I liked the witchcraft element, in particular.

LEFT: *Body Melt* (2019). This cover is for a curiously gross 1993 film I'd not seen before. The brief was to present the gruesome and gory nature of the film (it's also heavy on humour, albeit basic); however, I tried to weave in some of the corporate element by using the company logo that appears throughout the film.

FAR LEFT: *The Toxic Avenger Collection* (2016). This was a single composition that required elements from the 1984 title film and its three sequels. It required trawling through all four films at least three times: firstly to understand the basic plot; secondly to identify the key moments; and thirdly, to make the actual screen grabs for reference material. By giving prominence to the title character and keeping to a specific colour palette, I hoped that the result wouldn't be too much of an image overload. I've attempted to suggest narrative arcs, as far as the plots allowed.

ABOVE: *Cujo* (2019). This 1983 film about a rabid dog was one I'd never seen but was always aware of. By chance, it was on TV a few nights before I received the commission, but I missed the first half hour. When I was asked to create the limited edition slipcase, the client supplied a number of high-quality grabs to work from. I had no idea about the bat from my first viewing of the film, but it seemed an essential element of the story. It was hard to find a good image of the dog that didn't look sad or comical: I had to use a bit of "artistic license" to make it seem more threatening.

RIGHT: *Creepers* (*Phenomena*) (2011). My painting was originally commissioned for the limited UK theatrical release of a heavily cut version of this 1985 Italian occult horror. I'd watched the full film and had no idea that most of the climax featuring the monkey had been removed! However, the poster was printed and the VHS released. Arrow Video asked if they could use the art as part of the package for their release of the full feature. The monkey was back!

ABOVE: *Cohen & Tate* (2016). The central performances in this 1989 US thriller are exceptional, and the tension is often unbearable. For the cover, I'd hoped to capture something of the three main characters, who are bound together by their mutual mistrust and plotting. The extra elements are my attempt to add narrative and atmosphere without revealing the plot twists. In a rare instance of feedback from the director being passed on from the client, I learned that Eric Red was thrilled with the painting.

ABOVE: *Matinee* (2016). I liked the attention to period detail in this 1993 US comedy film, set in Florida amid the hysteria of the 1962 Cuban Missile Crisis, and wanted to evoke the feel of a B-movie poster with the atomic mushroom cloud and silly monster. It's one of the covers where I'm trying to tell a story through the images.

DVDS AND BLU-RAYS • 71

LEFT: *Cool Air* (2017). This adaptation of an H.P. Lovecraft tale had been shot in black and white and appeared in an anthology. My client (who also stars) decided to re-release the film as a standalone, using a colourisation process to create a "duochrome" effect. My illustration was designed both as a poster reward for a crowdfunding campaign and as the cover for the DVD release. Detailed images were difficult to grab from the material I was given, although the large portrait was sufficiently characterful to work from. I wanted to portray the tragic, sad expression whilst adding some threat. I found a separate reference for the typewriter, a crisp image that gave a good visual contrast to the softer image of the actors, almost as if viewing them through vapour.

RIGHT: *Funny Man* (2017). For the cover of this 1994 British horror comedy, the reclining "Funny Man" character was painted as a separate element, as requested by the client. The other elements were free for me to choose, as long as they included the legendary Christopher Lee, who co-stars. I'd originally intended to include Pauline Black (lead singer of the ska band The Selector), whose character provides some interesting narrative, but the image was getting too busy.

FUNNYMAN

LEFT: *Bloody Muscle Body Builder In Hell* (2017). Shot in 1998 by an amateur filmmaker, this is also known as "The Japanese Evil Dead" because it's essentially an even lower-budget version of that seminal supernatural horror, but with Japanese flavours. For the central bodybuilder himself, I googled the basic pose and grabbed what I could from the poor quality material to keep it true to the source. The additional elements are makeup effect highlights from the film, giving it as much "Evil Dead" as possible.

RIGHT: *Spider Baby* (2013). One of the pleasures of my work is viewing films I'd otherwise be unaware of. I immediately loved *Spider Baby* – a *very* black comedy horror – and was very excited to see Lon Chaney Jnr. in one of his last roles. I felt it necessary to pay homage to one of the final links to the Universal Classic Monster cycle (Lon Chaney Jnr. was best known as the "Wolfman"). Arrow Video passed on a message from the director, Jack Hill, who wanted to convey his happiness on seeing the new art. The colours were toned down for the release, to avoid any confusion about the film not being in colour. This is the version as I intended it.

LEFT, RIGHT; PAGES 78–79: *Seijun Suzuki: The Early Years: Vol 1 and Vol 2.* (2017). These two box sets of the '50s and '60s features directed by cult Japanese director Seijun Suzuki required a central portrait of him (only one was freely available, so I was instructed to reverse the headshot for Vol 2) surrounded by vignettes of characters and scenes from the films within. Each of the two Blu-ray sleeves within the boxes also required representations from the titles. A large array of mono images allowed me to pick and choose what I felt could be the most visually interesting, without my having to spend hours sitting through the films. That sounds a tad lazy, but the budget didn't buy the extra days required for an already complicated job. Besides, my screen grabs would have been inferior to the photography on offer.

DVDS AND BLU-RAYS • 77

DVDS AND BLU-RAYS • 79

Strip Nude For Your Killer (2019). With a contentious title and a problematic brief, I opted to give the cover of this 1975 Italian crime thriller a colour theme that wasn't obviously within the conventions of an exploitation film. A simple image of the victim and killer was required – although the film's twist couldn't be revealed – which made me less uncomfortable about the depiction. I repurposed the female pose from a previous job, adding the head of the film's actress (using a screen grab as reference). The killer was a hybrid of four different googled images.

FILM POSTERS

If my very first film poster (*The Monster Club*, 1981) still makes me embarrassed, the one I created for *The Evil Dead* (1982) offered me a career in film marketing that provides a wonderful format for any artist. Despite the technology that thrusts weird, artificially enhanced skin retouching and Photoshop-perfect images onto mainstream film promotion, there's a healthy interest in crafted posters that don't require literal interpretations to deliver their message. Illustration provides a mask for budget production, yet it also honours the legacy of cinema promotion in paint. Classic illustrated film posters remain highly collectable – they're not dusty relics but platforms for artistry and symbols of the very best of cinema's legacy. It's no coincidence that the rarest and most sought after film posters tend to be in the horror genre.

LEFT: *Depraved* (2019). I was asked to specifically create a poster in the original Universal monster movie style for this contemporary retelling of the Frankenstein story; there's particular emphasis on the Boris Karloff look that the "creature" is emulating (for which very precise photography was supplied as reference).

RIGHT: *Hallows Eve* (2016). A commission that expressly requested an image which conveyed the style aesthetic of a 1980s poster. My own poster for *A Nightmare On Elm Street* was a general reference point, and a small selection of production stills provided the specific reference. My brief included the need for a highly urban feel, including the graffiti element seen on the wall.

MOVIEHOUSE ENTERTAINMENT Presents A FILMIC MEDIA Ltd / INDIE FILMS Ltd Production
A film by BRAD WATSON

Tonight
they
take
the town.

HALLOWS EVE

MOVIEHOUSE ENTERTAINMENT Presents A FILMIC MEDIA Ltd / INDIE FILM LTD Production
HALLOWS EVE
SARAH AKOKHIA ETHAN TAYLOR LENOX KAMBABA
MATTHEW SWINNERTON SAVANNAH BAKER CHASE WILLOUGHBY JAN BOYE RUBY TUCKER FRANKIE CLARENCE CHLOE PAIGE HARDY
Sound Designer DAVIDE DEFENDI Visual Effects Supervisor JOHN ANDREW CAMERON Make Up Designer AMY PLAYFORD Production Designer KAY BROWN
Director of Photography ROBERT HORWELL Executive Producers TRISTAN THORNTON MARK VENNIS GARY PHILLIPS Produced by BRAD WATSON and ROBERT HORWELL
Written and Directed by BRAD WATSON MOVIEHOUSE ENTERTAINMENT

FAR LEFT: *The Black Gloves* (2017). A 1940s film noir look was essentially my brief for this film — the tale of a psychologist obsessed with the mysterious death of his young patient, and her belief in an entity called "the Owlman" — besides including the specific elements that form my composition. I went a bit wild with the colours.

LEFT: *Frankenstein's Creature* (2018). The focal points of this stripped-down feature — in which Frankenstein's creature delivers a monologue telling the story of Frankenstein from his perspective — are the central performance by the extraordinarily talented James Swanton and the atmospheric production by Sam Ashurst. A range of facial expressions was intended to deliver the tortured emotions of the manmade creature. I used one of my favourite colour combinations to suggest unnatural flesh tones and a sense of decay, even though the film is monochrome. I'll take liberties with content if I feel it creates a more engaging image (with the filmmaker's permission, of course!).

ABOVE: *The Old Dark House* (2018). Although the sleeve for the newly restored 4K release of this classic 1932 title was already determined (a reproduction of an original theatrical poster), Eureka asked if I'd be interested in creating a limited edition quad poster for the film, imagining this might be its first release. With such an incredible cast and range of characters, it was irresistible. An attempt to colourise the imagery would have been at odds with the film's rich, monochrome lighting; however, by using a limited palette, I hoped to retain respect for its use of chiaroscuro (light and shade) but with just enough colour to create a standalone image. I was delighted to present a copy of the resulting quad to Sara Karloff, who had expressed her pleasure at my representation of her father's character.

RIGHT: *Fantasma* (*Bloody Ballet*) (2017). This film was described to me as a homage to the Italian giallo films of Maria Bava and Dario Argento. Whilst keeping plot details opaque, an interplay of various characters was intended to evoke mystery and threat. The dominant red and blue colour theme is a direct reference to the dramatic lighting that defines the directors' best-known work. The eyeball on the blade signals the inclusion of set-piece murders.

FANTASMA

RED NEBULA AND ROUGH-CUT FILMS PRESENTS IN ASSOCIATION WITH V2 PICTURES AND CONTROLLED CHAOS 'FANTASMA' A FILM BY BRETT MULLEN WRITTEN BY MATT CLOUDE AND BRETT MULLEN SPECIAL EFFECTS BY JOH HARP FX ART DIRECTOR TINA REYNOLDS STARRING DEBBIE ROCHON KENDRA CARELLI BRETT WAGNER KATIE CARPENTER ROB SPRINGER SHANE TERRY AND CAROLINE WILLIAMS ASSISTANT DIRECTOR KEVIN WELCH CO-EXECUTIVE PRODUCER JOHN LANDOLFI AND BRETT MULLEN WITH MUSIC FROM UMBERTO AND NIGHTSTOP GUEST DIRECTOR MATT CLOUDE DIRECTED BY BRETT MULLEN

LEFT: *In2ruders* (2018). Originally written as a full-length feature, financial constraints demanded that for maximum production values, this would work best as a short film. With its overt visual references to the Italian giallo films of the late 1970s and psychedelia, there's a flavour of David Lynch, particularly in the creepy appearance of Spandau Ballet's Tony Hadley, who croons a ballad over the scene of a brutal murder. The soundtrack was written by Duran Duran's Nick Rhodes. With a bewildering array of potential visual elements for the poster, I attempted to create order by constraining the colours and composition to look like a stained-glass window, inspired by the works of the collaborative art duo Gilbert and George.

RIGHT: *The Void* (2015). Commissioned as one of a collection of posters by different artists, this surreal Lovecraftian film straddles the genres of horror and science-fiction. It's no coincidence that the makers are fans of *Phantasm*. With no specific brief, other than some early special effects designs and teaser trailer production shots, I opted for an enigmatic approach that ignores any narrative element.

88 • FILM POSTERS

ABOVE: *The Town That Dreaded Sundown* (2015). My poster is an illustrated version that had to incorporate elements of this remake of a film; the original film itself incorporates a fictional film, so in fact, it's three films! A pastiche and celebration of drive-in aesthetic, this art was printed as a strictly limited edition of 50 quad-sized posters for giveaway and competition wins. Both a poster for a film and a poster for a film represented within the film, it wears its exploitation credentials without shame!

RIGHT: *House Of The Gorgon* (2019). This joyous, low/no budget homage to Hammer Film's 1964 *The Gorgon* was made with the participation of four original Hammer actors, recruited by the sheer charisma of director Joshua Kennedy. It met with a great reception at a premiere screening at London's beautifully restored Regent Street Cinema (the home of "Pepper's Ghost" – an on-stage, live precursor to the world of cinematic special effects). My poster was designed as a pre-production crowd-funding tease. The two central leads are the director himself and Caroline Munro's daughter Georgina Dugdale. My brief requested a Hammer-style image showcasing the legacy talent and evoking the original *The Gorgon* colour palettes. The castle is a depiction of Burg Kreuzenstein in Austria, which by coincidence I later visited on a cultural tour with Victoria Price, Vincent's daughter. Despite the Bavarian setting the film was shot in Texas!

LEFT: *The Shadow Over Innsmouth* (2015). This was intended as a teaser poster for a film (to date unmade) by US filmmaker and sculptor Bryan Moore. An adaptation of the classic H.P. Lovecraft horror story about a lone traveller who gets more than he bargained for when he asks questions of the locals in a fishing town called Innsmouth, the film had already seen some early development, and I was furnished with excellent quality images of the vintage bus and the costume and makeup effects for its driver. My setting was created using my reference library of images from the British coastal towns of Whitby and Hastings. The green hues are suggestive of algae growth, seaweed and damp.

FAR LEFT: *Ghost Stories* (2019). I saw the stage play *Ghost Stories* twice in London, and Andy Nyman and Jeremy Dyson, who wrote and directed it, contacted me about creating portraits of them to appear in a quiz page in the play's programme. A couple of years later, I was asked to meet the pair to create some concept drawing for a film adaptation of the play. Although nothing further happened, I was invited to attend an early screening of the unfinished film with a small, selected audience. A couple of months later, I was invited to a screening of the completed picture, with the possibility of being involved in the film poster. Again, nothing happened. As part of their Blu-ray promotion of the film, Lionsgate got in touch about painting a poster for a limited edition release. Although the artwork exposure was limited, I did eventually get to make my mark on the production.

ABOVE: *The War Of The Worlds* (2019). This was among the many projects proposed by the late Ray Harryhausen, but despite his extensive pre-production work, it never went any further. A chance introduction led to a commission for a book of unrealised Harryhausen projects, and this is an imagined film poster for his film. I was particularly struck by one of the production drawings that depicted a scene in which the Martians appeared to be attacking an airship, the explicit reference being the Hindenburg disaster. I'd always been fascinated by airships and the 1975 Robert Wise film *The Hindenburg* is still one of my treasured viewings. Using this as a central image, I used Ray Harryhausen's creature and craft designs to bring this scene to life. The screaming girls in the foreground were appropriated from a vintage photograph of Beatles fans – I'm a magpie when it comes to reference.

RIGHT: *Inbred* (2012). I'd met director Alex Chandon at Frightfest in London and told him how much I'd enjoyed his film (my favourite of 2011's programme). Elsewhere, at a convention in Germany, I'd also met the producer, Yazid Benfeghoul. Although the eventual DVD release employed a generic Photoshop solution, Alex and Yazid approached me to consider my own illustrated version, a commission that required no persuasion. Described by the director as Mike Leigh meets *Deliverance*, the tone is very much in the tradition of British Folk Horror. The illustration eventually found some use in other territories. It's a particular favourite of mine.

ABOVE: *The Man Who Saves the World* (2019). I was asked if I would produce a poster for a series of film club screenings of this rarely seen 1982 film described as "The Turkish Star Wars". The film is unreleasable due to the unlicensed use of footage from a certain Lucas/Spielberg film. Filled with ludicrous costumes and rubber robots, there was no shortage of material to play with. Part *Forbidden Planet*, part *Flash Gordon*, I tried to create a suitably retro image that captured the ambitious yet curtailed scope of this breathlessly bad film.

RIGHT: *The Slayers* (2016). A low-budget independent film that mixes comedy and horror, for this I had only to include the key cast and have fun with the vampire theme. I used a mix of supplied production shots and screen grabs as reference. My colours were intended to give a playful look for the film, with a hint of Hammer Horror.

PAGE 98: *The Editor* (2015). I was initially approached by the producers to create some spoof giallo-themed posters that would appear as background props. The commission then extended to a poster for the actual film. For my concept of an actress draped across an editing desk as if it were a sacrificial altar, I was supplied with some great photography of the main cast and also specially created photography to use as reference. As if I needed persuasion, the director recorded a special request for my work by actor Udo Keir! I was honoured to attend the UK premiere at Sheffield's "Celluloid Screams" festival, alongside the Astron-6 team and actor Laurence R. Harvey.

MISCELLANEOUS

Occasionally, a commission doesn't fill a regular label. In this section of the book there are paintings that were used to package audio productions, licensed collectables and bespoke items. Throughout my career, I've illustrated packaging for ready meals, art products, health products and licensed toys – most of which are long forgotten (fortunately!).

LEFT: *Horror Pick 'n Mix* (2019). A writer's commission intended to cover a script to raise interest and funding. The concept was described in detail and needed to reference the poster for *Creepshow*. A sweetshop within a graveyard was the requested setting. While in Glasgow to attend Frightfest, I visited the Glasgow Necropolis, a wonderfully atmospheric Vctorian cemetery overlooking the city. The photographs I took there formed the basis of the backdrop for the art. I chose colours that were sickly sweet.

RIGHT: *Evil Dead II* (2017). An image created to act as a box cover for a series of licensed *Evil Dead II*-themed collectables. The only element that didn't pass the approval process was the green hues of Bruce Campbell's face – curious considering my poster for *The Evil Dead* featured a bright green Bruce Campbell! I allowed my client to recolour the face in Photoshop. Here's the original painting as intended.

100 • MISCELLANEOUS

LEFT: *The Mummy – Palimpset* (2016). A comic book cover variant under the Hammer brand. The key elements were briefed, and my sources included a human skull from my collection and a photograph of a friend, originally taken for another job. The intended second project, a variant for a *Captain Kronos* comic, had to be scrapped as the budget was unavailable.

RIGHT: *Puppet Master* (2017). An image created to act as a box cover for a series of licensed *Puppet Master*-themed collectables. Unlike the *Evil Dead II* box art, there were no image issues, and the art was used as it appears here.

MISCELLANEOUS 1993

ABOVE: *We're All Ears* (2015). I was aware of Larry Fessenden's work through the annual London FrightFest horror film festival; and in one year, Larry appeared as a guest. As well as being an actor, Larry is a prolific director and producer of horror films and is very supportive of new talent. It was a great honour to be asked by his company, Glass Eye Pix, to produce a series of illustrations for a collection of audiobook stories called *Tales From Beyond the Pale*. This particular image was non-specific but served as an introduction to the collection. The eight paintings that follow were based on loose sketches by Larry; I worked up the concepts as I saw fit.

ABOVE: *Little Nasties* (2015). In this audio play, a little girl attends a beauty pageant with her mother, only to learn that all the other contestants only come out at night.

ABOVE: *Guttermouth* (2015). A man hears voices coming out of his plumbing and is drawn inexorably into the tunnels beneath the city in which he lives. The only requested addition to my composition for this tale was the cockroach: it works perfectly.

ABOVE: *Food Chain* (2015). In this drama, four hunters set out to trap a Big Foot in the Appellation Mountains. This was one of two suggestions for the image – the other was a more graphic approach: a footprint with the toes/fingers represented by the silhouette of hunters with guns. I couldn't make it work, so we decided on the second, more literal, route. The setting was very specific; I sourced images of the woods from the web. My reference for the face used two separate images to give me what I wanted.

ABOVE: *The Hound* (2015). Here, a mysterious medallion leads to the ruin of two collectors of the macabre and exotic.

ABOVE: *Natural Selection* (2015). In this tale set on a remote Galapagos Island, a TV documentarian is bitten by a strange creature and begins a frightening metamorphosis.

LEFT: *Cannibals* (2015). A film producer interviews his young protégé and discovers they have more in common than their cinematic style.

LEFT: *Junk Science* (2015). This audio drama features a lone captain and his AI companion who travel past the Kuiper Belt towards a spaceship graveyard in order to salvage parts.

LEFT: *The Chambers Tapes* (2015). Seemingly innocent meditation tapes recorded in the '70s have a deleterious effect on those unfortunate enough to rediscover them. I used a bit of Photoshop work to enhance the dreamlike quality, softening the outer image.

PAGE 110: *Wendigo* (2015). My entry in a book of *Wendigo*-themed art compiled by Larry Fessenden. Various artists were asked to submit their concept of the mythological Wendigo creature, which is often depicted in a woodland setting. I decided to use the desolation of an icy, barren landscape. I wanted to convey a sense of loneliness and melancholy: a creature imprisoned in its own "otherness".

POSTERS

Posters for films are a familiar part of the urban landscape; their origin in theatre posters and even stained-glass windows is a testament to the colourful call to congregations and audiences alike. Similarly, events and appearances are easily announced with poster campaigns, both in print and online. Laptop screens and mobile phones are the new walls. A printed poster, however, can be framed, signed and collected. When photography fails to convey a true sense of anticipation, the painted image can deliver a colourful promise with theatrical flair. Once an event has passed, the poster serves as a souvenir and a conduit to enhanced memories.

ABOVE: *Sheffield HorrorCon 2017*. The first of my three posters for this annual event depicts the invited guests, but with the addition of an extra element that honours the location. In the 19th century, the South Yorkshire city of Sheffield became world-renowned for the quality of its steel. This was the direct result of its investment in a machine and surrounding process developed by Henry Bessemer – later known as the Bessemer converter – which enabled the inexpensive mass-production of steel from molton pig iron. My depiction of the Victorian inventor's converter is reimagined as a blackened skull.

ABOVE: *Sheffield HorrorCon 2018*. This second poster has a common thread in that a number of the guests have produced films featuring a supernatural book: either *The Necronomicon*, *The Book of Eibon* or *The Three Mothers*. The backdrop is Sheffield's own Gothic cemetery.

RIGHT: *Sheffield HorrorCon 2019*. Although the third poster celebrates the monstrous characterisations of some of the guests, the extra element is a loose representation of a devil-like entity called Spring-Heeled Jack. Though mostly known as a scourge of London and the Southeast in the 1830s, Spring-Heeled Jack also briefly appeared in Sheffield in 1873… and again, reportedly, in the 1970s!

SOMETHING WICKED HORRORCON UK

www.horroruk.com

11th & 12th May 2019
MAGNA SCIENCE ADVENTURE CENTRE

| DARIO ARGENTO | JOHN CARROLL LYNCH | COREY FELDMAN | EDWIN NEAL | DENIS O'HARE | SEAN PERTWEE | VICTORIA PRICE | DUNCAN REGEHR | JENNIFER RUBIN | SCOUT TAYLOR-COMPTON |

LEFT: *The Ghost Train Doesn't Stop Here Anymore* (2016). Much in the manner of the Amicus films made during the 1970s in which unrelated stories were unified by a central framing device — a crypt, a train, a house, etc. — this was a theatre play written by a number of genre writers who used the Ghost Train as its link. Performed in the intimate space of the Trystan Bates theatre in Soho, London, the short run brought together a variety of talents. Each of the play's segments featured a reference to a classic horror trope, so I made use of some recognisable faces, knowing that the budget production would not cause any significant infringements.

RIGHT: *A Night of a Thousand Vampires* (2019). On one level this is a concert poster, but with the collaboration of Hammer Films and The Circus Of Horrors, it announces no ordinary show. Dave Vanian, singer with the band The Damned, briefed the concept of a turn-of-the-century theatre poster and 1930s/40s classic horror poster. Using the theme, I used reference from photographs I'd taken at Whitby Abbey, and sourced several images, including a 1920s seaside reveller to whom I added bat wings; a graveyard damaged by a hurricane; and Vanian's own daughter in vampire makeup. The limited colour palette conveys an early litho printing process. By encouraging the audience to dress as vampires, we hope to break the world record for the largest gathering of people dressed as vampires — with Vanian himself arriving in a horse-drawn hearse. At the time of going to press, the event has yet to take place!

28th OCTOBER 2019

HAMMER HOUSE OF HORROR presents

The Damned

At The LONDON PALLADIUM
in
'A Night of a Thousand Vampires'

featuring THE CIRCUS OF HORRORS

THE LONDON PALLADIUM
LW THEATRES

FRIGHTFEST 2016

THE FEU FOLLET CINÉMA FLOTTANT
FÊTE DE LA PEUR

ABOVE: *FrightFest 2016*. In this year, the London Frightfest — the annual celebration of horror in cinema featuring screenings, on-stage interviews and appearances by the filmmakers — had to relocate. I tried to find a horror-themed link with the new location, but nothing presented itself, so I took the concept of a moving cinema. I imagined a haunted Louisiana swamp, with a witch's house and a sinister paddle steamer serving as a travelling theatre. Included are the fire spirits (Feux Follets) often seen dancing over swamp waters.

LEFT: *FrightFest 2019*. Emerging each year from the charnal grounds, the monster tears open his own flesh to reveal the FrightFest numerical milestone: now the 20th year! Using the stylistic inspiration of press ads for the Aurora 'glows in the dark' model kits of the early '70s, four ghastly apparitions (in fact, the four organisers of the festival!) flank the creature, each a-glow with sinister light.

RIGHT: *FrightFest 2018*. This year was the 200th anniversary of the publication of Mary Wollstonecraft Shelley's book *Frankenstein*, without which it's difficult to imagine how the horror landscape in popular culture might now look. For the 9th FrightFest, I'd created a character that could continue to evolve with future posters. In this instance I wanted to pay homage to *Frankenstein*, but also acknowledge the new sponsor, Arrow Video, with clues to the label's latest releases.

Catch of the Day
Who Shot The Coach?

OUTPOST 31

PINS

BELOW. *Blood Drive* (2017). This TV series was announced for the US-based SyFy channel. I was approached to paint a poster which (as I interpreted the brief) would link the series to its roots in the work of Roger Corman and B-movie cinema. There were a number of key characters who had to be included, and high-quality photographs were provided for my reference. Part of the challenge was to compose a layout that would work in a variety of formats, both portrait and landscape. Because of the level of detail required, it was necessary to paint the image in two sections and join them in Photoshop. Represented here is the widest format. The main poster features only the main cast, on the right. The brief required a white background, but when I began my painting I used a wash of colour across the entire base (my usual process). I sent progress shots to the client, and when I'd completed the image, I painted out the base wash in opaque white to fulfil the brief. By this point the client had decided they liked the background wash, so I had to paint a new base that I could add in Photoshop to create the illusion of the original.

POSTERS • 119

LEFT: *The H.P. Lovecraft Bronze Bust Project* (2014). Social media has been instrumental in widening exposure to my work, particularly in the US. The channels provided an introduction to sculptor Bryan Moore through filmmaker Jovanka Vuckovic, and I was approached to provide a portrait of the horror and sci-fi writer H.P. Lovecraft to drive the crowd-funding for the creation and installation of a bronze bust of him at the 19th-cenury Providence Athenaeum library in Rhode Island. I'd begun reading Lovecraft's work at secondary school, and his writing helped inspire my career, so this was a chance to honour his work. The funding was secured and Lovecraft's likeness in bronze is now at the very library he himself frequented.

ABOVE: *The Edgar Allan Poe Bronze Bust Project* (2014). Another visitor to the Providence Athenaeum was the master of the macabre, Edgar Allan Poe. After the success of the Lovecraft project, Bryan Moore chose Poe for his next bronze bust project. Again, the campaign was successfully funded, which provided the opportunity for me to attend the unveiling at Boston Public Library. In addition, another supporter of the project, actor Jeffrey Combs, performed at a nearby theatre his deeply affectionate and unexpectedly amusing one-man show — a re-creation of a Poe recital — as part of the celebration.

ABOVE: *The Bram Stoker Bronze Bust Project* (2016). The third horror genre writer to receive the bronze bust honour is best known for his book *Dracula*, which, alongside Mary Wollstonecraft Shelley's *Frankenstein*, remains among the most famous horror tropes in popular culture. Funding proved more difficult to secure for this bust, presumably because Stoker was not an American (in a largely US-based project) and his other work is less known to the wider public. Nevertheless, thanks to the participation of Bram's great-grandnephew, Dacre Stoker, the busts were cast: one is now installed in the Seattle Museum of Popular Culture, while the other resides at the Writer's Museum in Dublin, Ireland.

Tomorrow's Ghosts Festival

28 APRIL 2019 AD

HAMMER GLAMOUR

Women of Horror
with
Dacre Stoker
& The Secrets of Dracula

Whitby Pavilion • 1pm • £10

ABOVE: *Hammer At The Vault* (2012). As a huge fan of the Hammer Horror films that I recall seeing on my portable, mono TV during my early teens, then much later after I'd bought my first colour TV (12-inch screen and four channel buttons!) in full lurid colour, I leapt at the chance to paint this homage to the UK's most famous purveyors of screen horror. A series of screenings would take place in the vaults beneath Waterloo station: the underground labyrinth originally built to support the new station on the marshland beneath. Housed within its depths was a smaller station that served the "Necropolis Railway", built to convey corpses to Brookwood cemetery, some distance beyond London's boundary. The room in which the films were to be screened had been used to store the corpses awaiting their final journey on public transport. Organised by the literature/film "Flicker Club", each screening was to be preceded by a reading from the book that had provided the source material for the screenplay: *The Hound Of The Baskervilles*, *Frankenstein*, *The Woman In Black*, and so on. As each film had to be in ownership of the current Hammer license, only particular titles could be represented. Peter Cushing's Frankenstein had to be from *Frankenstein And The Monster From Hell*, Christopher Lee's Dracula from *Dracula Prince Of Darkness*, and so on. The only client error was in including *Countess Dracula* on the initial list. It transpired that the title was not in ownership, and therefore a patch featuring one of the *Twins Of Evil* had to replace my portrait of Ingrid Pitt, the actress who played the Countess.

LEFT: *Hammer Glamour* (2019). Commissioned by the festival organiser to celebrate the Hammer guests and setting of Whitby, Yorkshire – as made famous by the novel *Dracula* – with the special guest addition of Dacre Stoker, great-grandnephew of Bram Stoker.

POSTERS • 123

LEFT: *Yield Up the Mystery Tour* (2018). Whilst not a commission, I decided to paint and design this poster as a giveaway for participants of a group tour of locations related to the Vincent Price film *The Tomb Of Ligeia* and various supernatural connections. Only 20 were printed, each signed by the hosts and myself.

RIGHT: *The Vincent Price Legacy Tour* (2017). This poster was initially offered in a limited run to celebrate a series of events based around the films Vincent had made in the UK. Each is represented with a view to maximising visual impact, according to the reference available (the highest quality taking priority). Price's only role not represented in the poster was that in *Cry Of The Banshee* (1970). I decided to represent the Banshee, but with little available reference, I reduced the figure and substituted the costume for that worn by Oliver Reed's character in *Curse Of The Werewolf* (1961): essentially the same clothing. (I was surprised that so many people picked up on this – a testament to Reed's enduring performance, I guess!).

THE OAKLEY COURT
FILM & MEMORABILIA FAIR

LEFT: *An Evening with Martine Beswick* (2018). A promotion and limited edition souvenir poster for a Misty Moon event. The portrait is from the film that was screened prior to an interview and Q&A with Martine, an English actress and model best known for her roles in two James Bond films.

FAR LEFT: *The Oakley Court Film and Memorabilia Fair* (2019). Many of the early Hammer films were shot around the Victorian Gothic Oakley Court in Windsor, located next to Hammer's Bray Studios, and often featured its exterior. Intended as a promotion for the second Oakley Court film fair, this poster celebrates some of the memorable films that featured the building (now a hotel); *The Rocky Horror Picture Show* (1975) used it extensively. The event was also a launch platform for Arrow Films's Blu-ray release of José Ramón Larraz's 1974 film *Vampyres* (also shot around Oakley Court). The depiction of the film's two leads at the base of the poster would not otherwise have been included. I always try to pick reference material that's expressive and evocative.

POSTERS • 127

LEFT: *Vulcan 7* (2018). This illustration incorporates the three characters that appeared in a stage play starring Adrian Edmondson and Nigel Planer (of *Young Ones* fame). At the time of commission, there was no costume yet built for Adrian's character (an actor in an undignified monster suit), so I had to imagine from the description given, how it might appear (without the mask, to capitalise on the real actor's portrait). The play was described as "a Beckettian comedy about two past-it thesps making a sci-fi film on the edge of an Icelandic volcano", and its poster had to feature the cast (in part makeup), a trailer, a damaged bridge, a volcano and a helicopter rescue, in a Bond poster pastiche. Photographic reference was supplied of Nigel Planer in a butler costume and Adrian Edmondson in a black T-shirt pulling the required face.

RIGHT: *Manhunter/Trick 'r Treat* (2013). This poster was painted to promote a special screening of these two films starring Scottish actor Brian Cox, who was attending the event to be interviewed on stage. The image takes elements from both films.

128 • POSTERS

SATANIC MOJO 1972AD

LEFT: *Jason: Kane Hodder* (2014). A print created for sale at Germany's Weekend Of Hell horror convention, where Kane Hodder (who played Jason in three of the *Friday the 13th* franchise films) was one of the many guests.

FAR LEFT: *Satanic Mojo 1972 AD* (2015). An imagined poster for a fictitious film that incorporates elements prescribed by my friend Jason Atomic for his magazine *Satanic Mojo*. This particular edition came in the form of a fold-out poster. Jason joked that this was his "family portrait", as it features both his girlfriend and their cat. Being such a unique representation, I decided to make a gift of the artwork to the "family".

POSTERS • 131

Left: *An Evening with Ian Ogilvy* (2018). Promotion and limited edition souvenir poster for a Misty Moon event. An interview and Q&A followed the screening of the 1968 historical horror film *Witchfinder General*, based on Ronald Bassett's novel of the same name, which is about the murderous exploits of English witch-hunter Matthew Hopkins.

Far Left: *An Intimate Evening with Linzi Drew* (2019). Promotion and limited edition souvenir poster for a Misty Moon event. The image incorporates Linzi's work with Ken Russell (in this instance *Aria*) and her role in *See You Next Wednesday*, the fictional sex film that appears in a key sequence in *An American Werewolf in London*.

POSTERS • 133

LEFT: *Fabio Frizzi: The Beyond Tour* (2016). Commissioned directly by the Italian composer to promote his tour of the soundtrack for the 1981 film *The Beyond* performed live. No specific brief other than to include portraits of himself and the film's director, Lucio Fulci. The additional elements are references to the film (including the blind eyes).

RIGHT: *Fabio Frizzi: Zombie Apocalypse Tour* (2016). A touring tribute to Lucio Fulci, with performances of Fabio Frizzi's soundtracks of the director's horror films. The concept for the poster came from the tour management.

FAR LEFT: *Weekend of the Dead* (2017). This festival poster was commissioned by a friend I'd met at a horror convention in Germany, the year before. Weekend Of The Dead celebrates the legacy of George A. Romero, best known for his zombie films – Romero's *Night Of The Living Dead* (1968) defines the contemporary zombie genre. Due to work commitments, I was unsure about accepting the job. Once I'd learned, however, that actor John Amplas was a confirmed guest (his lead role in the 1978 psychological horror film *Martin* had left a deep impression), I took the opportunity to give his portrait top billing. Effects pioneer Tom Savini, was a later addition to the guest list, I was asked to patch in an extra portrait – the only space available was on the TV screen.

LEFT: *Weekend of the Dead* (2018). My second poster for the annual event. Faced with the prospect of depicting a large number of guests, it seemed pointless to fill a poster with so many portraits without any focus. I'd invited a colleague to pose as my flesh-eating zombie in the first poster and decided he'd provide perfect continuity. Repeating the motif of an old TV set (many Romero fans would have first watched his films on VHS and a cathode ray box), I incorporated a portrait of George A. Romero himself, who'd just passed away. The "8" motif is rammed home in the tag line and the use of night and dawn (full moon and sunrise) within a large numeral eight.

POSTERS • 137

ABOVE: *The Return Of The Living Dead/Re-Animator* (2013). A poster designed for an event that included the screenings of two 1985 comedy horror films, *The Return Of The Living Dead* and *Re-Animator*, and an on-stage guest appearance and interview with Don Calfa (Ernie from *The Return Of The Living Dead*). In my image, the actor is in character as Ernie, holding the half corpse featured in a key sequence and the head from a central character in *Re-Animator*.

138 • POSTERS

PRIVATE COMMISSIONS

A thriving market for bespoke posters and limited editions has provided an outlet for reimagined interpretations and tailored designs. Whilst private commissions for individuals might be beyond the reach of most collectors, groups are formed to spread the cost, which allows for the production of limited runs that aren't in the public domain. These are not-for-profit posters that don't directly challenge licensing issues or attract litigation. Most are simply expressions of love for a treasured title and allow artists to celebrate a film, free of marketing directives. Occasionally they may spill into the mainstream with licensed use; for example, in this section, the *Halloween* poster was licensed for an official T-shirt; *What We Do In The Shadows* was licensed for a special screening; and *An American Werewolf In London* has been licensed for a special edition re-issue.

LEFT: *An American Werewolf in London* (2017). In response to the limits imposed by Paul Davis's book *Beware the Moon* (see page 24) about the making of the film, this was a chance to go full throttle with the imagery. My original concept included the rotting Jack and the monstrous killers in David's dream sequence, but my client didn't like these. The wolf transformation was a last-minute concept... that I've since seen tattooed on someone's arm!

RIGHT: *Poltergeist* (2016). This was the first of a series of private commissions from an individual. A basic list of elements that should be included presented no problem, and I added some of my own. I wanted to play up the horror elements as much as I dared, without losing the feel of the 1982 supernatural horror.

140 • PRIVATE COMMISSIONS

142 • PRIVATE COMMISSIONS

TOP LEFT: *The Evil Dead* (2014): Seeking new imaginings of older film posters, a group approached me to consider creating a new version of my original poster for this cult classic. It seemed like a fair challenge. I knew that the colours would have to be completely different and that the Ash character should become central (in my original, the character was an unknown). I tried to keep the raw feel of the original, and I also included the tape reels as a nod towards it. This poster was printed in a very limited edition for the group. As a screen print, the colour-separating process was crucial and required about 16 inks.

BOTTOM LEFT: *Evil Dead II* (2014). Interest in the first commission led to this sequel reimagining. Again, I tried to make it very different to my original, including new elements and reflecting the larger budget of the 1987 film.

ABOVE: *Army of Darkness* (2016). This poster completes the screen print trilogy. I'd not worked on any previous campaign for this 1992 black comedy, a sequel to *The Evil Dead* and *Evil Dead II*, so I was able to imagine how I might have approached it at the time, without any baggage. By the time *Army of Darkness* was made, Bruce Campbell (in the role of Ash) was entirely central to the franchise, so my layout tried to reflect this.

TOP RIGHT: *In the Mouth of Madness* (2019). This poster was for a film I'd always liked and found extraordinarily unsettling, and the group commission gave me a chance to explore that creepiness. The only constraint was to keep the blue hues, but I'm happy with the overall effect.

RIGHT: *Soulmate* (2015). Commissioned by director Neil Marshall (*Dog Soldiers*, *Doomsday* and *The Descent*) as a gift to his director wife Axelle Carolyn to mark her debut feature. It was an open brief for me to interpret as I wished.

SOULMATE

ABOVE: *What We Do In The Shadows* (2015). In this group commission, I was asked if I'd be interested in my own take on the title. I'd seen the film several times and leapt at the chance. I loved the characters, each with his own vampire identity. It would have been futile to ignore the opportunity to represent these four very individual portraits. I thought it would be funny to make the new vampire character little more than a bat – not quite ready to join the established group – and I also decided to give each vampire his own colour theme.

RIGHT: *The Thing* (2019). Another commission from an individual. As with the *Halloween* artwork (created for the same client; see page 150), I was intimidated by attempting to capture a film that's become part of cinema history, complete with loaded expectations and a wide, protective fanbase. The 1982 sci-fi horror has also been interpreted in many different images, so it was difficult to find an original way through. Ultimately, I just used my instincts. Deciding that the "flying saucer" had been unrepresented in most versions, I made it a prominent feature. In essence, the flying saucer is part of a religious icon – the haloed saviour surrounded by hellish visions.

146 • PRIVATE COMMISSIONS

148 • PRIVATE COMMISSIONS

FAR LEFT TOP: *Night of the Creeps* (2016). I'd illustrated a VHS cover for this 1986 title on its first release, so I was very familiar with the content. Re-watching it after so many years, I was surprised at how well the sci-fi/comedy/horror stood up, and how exciting the visuals were. I wanted to throw everything into the poster — and almost did!

FAR LEFT BOTTOM: *Thriller, A Cruel Picture* (2014). Although I knew of this 1973 exploitation film, I'd never actually seen it. This commission came from an individual in Sweden, where the film originated. I was lucky enough to meet star Christina Lindberg when she was a guest at the Glasgow FrightFest in 2019. A quad-size copy of this poster hangs in her home!

LEFT: *Dracula/Van Helsing* (2012). This was painted for an auction at a weekend celebration of Hammer films arranged by the De Montfort University in Leicester, UK, home of the Hammer Archive. Christopher Lee and Peter Cushing are represented in the roles that defined their career.

PAGE 150: *Halloween* (2016). It's always daunting to take on a classic of the genre, and the 1978 original of the *Halloween* franchise has seen so many interpretations there was little room for anything new. I knew that there was one scene rarely (if ever) represented: the raising of the tombstone. I also wanted to portray the young Michael Myers in the clown suit, as well as the monster he becomes. Never forgetting the title, I decided to make the pumpkin the dominant foreground element, creating a layered effect. I took some timed photographs of myself holding a piece of wood for the main Michael Myers pose.

PRIVATE COMMISSIONS • 149

THE NIGHT HE CAME HOME!

SMITH'S GROVE SANITARIUM WARREN COUNTY

HALLOWEEN

MOUSTAPHA AKKAD PRESENTS DONALD PLEASANCE IN JOHN CARPENTER'S 'HALLOWEEN'
WITH JAMIE LEE CURTIS P.J. SOLES NANCY LOOMIS WRITTEN BY JOHN CARPENTER AND DEBRA HILL
EXECUTIVE PRODUCER IRWIN YABLANS DIRECTED BY JOHN CARPENTER PRODUCED BY DEBRA HILL

RECORD COVERS

At the beginning of my career, record covers were among the most collected and affordable forms of artwork. Often, records were purchased simply for their cover art (just like movies!). But then came CDs, with their diminished platform, to be followed by blank downloads. To the surprise of everyone, however, vinyl has made a comeback. This resurgence proved that the format was not just "undead", but finding a new market. Much like private commissions of film posters, vinyl has opened up a format for reimagined soundtrack art, while allowing bands to release their music in a physical, collectable form.

ABOVE AND RIGHT: *Vault of Horror: the Italian Collection Vol 1 & 2* (2017/2019). Each of these double albums required images from the soundtracks showcased within. With so much imagery to pick from, I had to be guided by what I knew to be fan favourites and concentrate on those elements. But I was limited by the quality of available materials for reference. Inevitably, the best quality images are the focal ones.

152 • RECORD COVERS

RECORD COVERS • 153

ABOVE: *The Zero Boys* (2017). In order to provide the gatefold for this album of the original soundtrack of the 1986 film, I had to extend the art from a Blu-ray cover. Although I could never determine which genre the film fitted into, I ran with the elements that seemed most appropriate.

154 • RECORD COVERS

RECORD COVERS • 155

LEFT: *Caltiki* (2017). The art for the soundtrack album of this early (1959) Mario Bava film was originally painted for a Blu-ray case. For the gatefold, I had to extend the art to a back panel with new imagery to match the look of the front. The film is black and white, and I used a limited palette so as not to create a false impression.

RIGHT: *The Evil Dead – A Nightmare Reimagined* (2018). A new recording of the original compositions for the soundtrack of the film. The top image is the back and front of a gatefold sleeve; the second image is the inner double spread. With an open brief, I decided to create a visual narrative, with the front panel representing the early section of the film, gradually taking the events through to the bloody climax. I purposely chose the outside palette to be as different as possible to my original 1983 UK quad poster.

RECORD COVERS • 157

ABOVE: *Gates of Hell Trilogy* (2018). I'm not sure if this saw the light of day, but it was commissioned for a soundtrack CD featuring music from the three Lucio Fulci films (*City of the Living Dead*, *The Beyond* and *The House by the Cemetery*). I recall that the brief requested the three heads.

ABOVE: *The Devil Rides Out* (2012). Commissioned but never released, this soundtrack art remains unused. The film was released in 1968 and is based on the 1934 novel of the same name by Dennis Wheatley. It's a late Hammer favourite. The imagery came to me in a dream, every part reproduced as well as I could recall it. Spooky!

RECORD COVERS • 159

RIGHT: *The League of Gentlemen* (2018). As a fan of the British TV series, this commission was a dream job. I knew there would be a lot of work involved (a box, four sleeves, each with three LPs, plus 24 labels), and that I was going to handle all the design aspects as well as illustrate. I found a way through, however, and with input from the client, I met the deadline. The radio series was new to me; some of the characters hadn't yet been developed for the later TV show, whilst some were very different. But using imagery from the TV series I was able to imagine how it could have been as a TV show.

ABOVE: *The League of Gentlemen Live Again!* (2019). Whilst each of the previous LP sleeves were conceived as if they were film soundtracks from the 1960s/70s (particularly the design on the back of the sleeves – not shown here), the 'Live Again!' vinyl release was intended as a completely separate limited edition for the UK Record Store Day; I did, however, retain the basic design format. Weirdly, it all looks very religious!

RECORD COVERS • 161

ABOVE: *Erik the Conqueror* (2017). Another Blu-ray sleeve extended to create the gatefold LP format. I wanted to capture a classic film poster look for this epic Viking film from 1961 directed by Mario Bava, but my own style always takes over!

162 • RECORD COVERS

ABOVE: *Autopsy* (2017). This 1975 Euro-crime film was completely unfamiliar to me, but the chance to work on an Ennio Morricone soundtrack made the commission especially attractive. I decided to follow the avant-garde direction of the music with a brutal approach to the imagery and colour.

ABOVE: *Untouchable Glory – Gama Bomb* (2015). This is the second LP cover I've painted for the northern Irish thrash metal band. This one required a number of very specific poses and elements, and photographic reference was provided for the band members. The look was intended to evoke action posters from the 1970s.

RECORD COVERS • 165

ABOVE: *Other Worlds Other Monsters* (2017). This album by British experimentalist musician Andrew Liles journeys into the world of '70s and '80s science-fiction soundtracks. A specific brief required the cyborg effect (Andrew's face) and the inclusion of his wife (to the left).

166 • RECORD COVERS

ABOVE: *Ticket to Rock – Daxx Roxanne* (2017). One of those friend of a friend connections brought me to this cover. Apparently, some work had been progressed on cover concepts for this, the band's first LP. Although they had a title, and thus a loose theme, I took my own direction with it (inspired partly by the song titles and lyrics), and fortunately found favour. A more pleasant group of gentlemen you could not meet.

ABOVE: *Tales from Thee Creepfreaks* (2018). This cover art was commissioned by a colleague who was also the drummer in London psychobilly band Thee Creepfreaks. A nod to the US horror comics of the 1960s, it was great fun to work on, and a pleasing swap for the design and build of my website! Thank you, Jeremy.

168 • RECORD COVERS

ABOVE: *Fabio Frizzi – Frizzi 2 Fulci Undead in Austin* (2016). For this CD of a live recording of composer/musician Fabio Frizzi's performance in Austin, Texas, the Italian distributor commisiond me to create the look of a zombie film, using the location of the recording and an image of Frizzi. I corralled a number of work colleagues to pose as zombies. The *Shrek* ears were a friend's way of letting colleagues know she was not to be disturbed... she'd forgotten to remove them, but I thought they were too funny to leave out.

RECORD COVERS • 169

ABOVE: *The Beast In Space* (2017). This Italian film is a curious intergalactic sex romp, heavily influenced by a certain successful mainstream hit, and I could approach it only as an exercise in B-movie camp. The central gatefold image of the soundtrack (RIGHT) was painted at the request of the client and is a challenge to good taste. It is, however, an accurate depiction of a character in the film.

170 • RECORD COVERS

ABOVE: *The Conqueror Worm* EP (2019). This began as a music project for some friends and included the voice of a rarely heard Vincent Price reading of a poem by Edgar Allan Poe. It seemed wrong not to make it available on vinyl. Originally intended as a 7-inch single, the track was too long and required the 12-inch format. The edition was 300 units on green vinyl. I decided to capture two eras of Vincent Price: the cover is a pastiche of his mid-career work and a nod to the Roger Corman films in which he collaborated. The reverse is a more playful *The Abominable Dr. Phibes*-era (early 1970s) portrait.

ABOVE: *Pop The Bubble – Dolls* (2018). This is the cover of an EP by a female grunge-punk duo. Using the lyrics as my inspiration, the idea was to create a subversion of a retro ice-cream advertisement.

172 • RECORD COVERS

INTRODUCTION/BOOK COVERS

The Karloff Compendium, created for the limited edition book *The Karloff Compendium* by Stephen Jacobs © 2019 Unstoppable Editions/Unstoppable Cards
Beware The Moon: The Story of An American Werewolf In London © 2017 Dead Mouse Productions
Lost In The Shadows: The Story of The Lost Boys © 2017 Dead Mouse Productions
Cult Cinema: An Arrow Video Companion © 2016 Arrow Video
A Century Of Horror © 2018 We Belong Dead
Spotlight on Horror © 2019 We Belong Dead
Undead Uprising © 2016 Strange Attractor Press
245 Trioxin: The Story of The Return Of The Living Dead © 2016 Dead Mouse Productions
Defying Gravity: Jordan's Story © 2019 Omnibus Press
A Celebration of Vincent Price © 2019 We Belong Dead

DVDS AND BLU-RAYS

Bombshell Bloodbath © 2014 Red Nebula
Attack Of The Adult Babies © 2018 Nucleus Films
The City Of The Dead © 2016 Arrow Video
Asylum © 2019 Second Sight Films
Mark Of The Devil © 2014 Arrow Video
The House That Dripped Blood © 2019 Second Sight Films
The Man Of A Thousand Faces © 2019 Arrow Video
The Fall Of The House Of Usher © 2013 Arrow Video
Phantasm I & II © 2017 Koch Films
Phantasm III: Lord Of The Dead © 2017 Koch Films
El Topo © 2007 Tartan Video
Nikkatsu Diamond Guys Vol 1 & 2 © 2016 Arrow Video
Willard/Ben © 2017 Second Sight
Worst Fears © 2016 Nucleus Films
Evil Ed © 2017 Arrow Video
Dr. Giggles © 2017 X-Cess
The Witches © 2017 Arrow Video
Return To Nuke 'Em High Vol 1 ©2014 84 Entertainment
Inferno © 2013 Arrow Video
The Barn © 2017 Nevermore Production Films
Horror Express © 2018 Arrow Video
Howling II © 2016 Arrow Video
Shock Treatment (variant 1 & 2) © 2018 Arrow Video
Schlock © 2018 Arrow Video
Return Of The Living Dead Part II © 1984 Metro-Goldwyn-Mayer Studios Inc. All Rights Reserved.
Necronomicon © 2019 Wicked-Vision
Hired To Kill © 2016 Arrow Video
The Best of '80s Scream Queens © 2018 88 Films
The Count Yorga Collection © 2016 Arrow Video
The Stuff © 1985 New World Pictures
Kill, Baby… Kill! © 2017 Arrow Video
Body Melt © 2019 88 Films
The Toxic Avenger Collection © 2016 88 Films
Cujo © 2019 Eureka Entertainment
Creepers (Phenomena) © 2011 Arrow Video
Cohen & Tate © 2016 Arrow Video
Matinee © 2016 Arrow Video
Cool Air © 1999/2017 Arkham Cinema LLC
Funny Man © 2017 Screenbound Pictures
Bloody Muscle Body Builder In Hell © 2017 Terracotta Distribution
Spider Baby © 2013 Arrow Video
Seijun Suzuki: The Early Years. Vol. 1 & 2 © 2017 Arrow Video
Strip Nude For Your Killer © 2019 Arrow Video

FILM POSTERS

Depraved © 2019 Glass Eye Pix
Hallows Eve © 2016 Movie House Entertainment
The Black Gloves © 2017 Hex Media
Frankenstein's Creature © 2018 Sam Ashurst
The Old Dark House © 2018 Eureka Entertainment
Fantasma © 2017 Red Nebula
In2ruders © 2018 Trailblazer Films
The Void © 2015 Cave Painting Picture
The Town That Dreaded Sundown © 2015 Metrodome
House Of The Gorgon © 2019 A Gooey Film Production
The Shadow Over Innsmouth © 2015 Arkham Cinema LLC
Ghost Stories © 2019 Lions Gate Entertainment Inc.
The War Of The Worlds © 2019 The Ray and Diana Harryhausen Foundation (Charity No SC001419)
Inbred © 2012 New Flesh Films and Split Second Films
The Man Who Saves The World (Turkish Star Wars) © 1982/2019 Anit Ticaret
The Slayers © 2016 John Williams.
The Editor © 2015 Kennedy/Brook Inc.

MISCELLANEOUS

Horror Pick' n Mix © 2019 Nicholas J. Murgatroyd
Evil Dead II © 2017 Phantasma: a Middle Of Beyond Company / Rennaissance Pictures
The Mummy © 2016 Titan Publishing Group Ltd
Puppet Master © 2017 Phantasma: a Middle Of Beyond Company / Full Moon Pictures
We're All Ears © 2015 Glass Eye Pix
Guttermouth © 2015 Glass Eye Pix
Food Chain © 2015 Glass Eye Pix
Little Nasties © 2015 Glass Eye Pix
The Hound © 2015 Glass Eye Pix
Natural Selection © 2015 Glass Eye Pix
Cannibals © 2015 Glass Eye Pix
Junk Science © 2015 Glass Eye Pix
The Chambers Tapes © 2015 Glass Eye Pix
Wendigo © 2015 Glass Eye Pix

POSTERS

Sheffield HorrorCon 2017; 2018; 2019 © Graham Humphreys Ltd.
The Ghost Train Doesn't Stop Here Anymore © 2016 Bad-Bat
A Night Of A Thousand Vampires © 2019 Graham Humphreys Ltd/The Damned
FrightFest 2016; 2018; 2019 © Graham Humphreys Ltd
Blood Drive created for the SYFY Television Series Blood Drive © 2017 *Documentary* © 2019 CreatorVC
H.P. Lovecraft Bronze Bust Project © 2014 Arkham Studios
Edgar Allan Poe Bronze Bust Project © 2014 Arkham Studios
Bram Stoker Bronze Bust Project © 2016 Arkham Studios
Hammer At The Vault © 2012. (UK publicity material for *Frankenstein And The Monster From Hell, The Quatermass Xperiment, Twins of Evil*: copyright 1955–1974 Hammer Films Legacy Ltd. UK publicity material for *The Lost Continent, The Plague Of The Zombies, Dracula Prince of Darkness, The Reptile, The Witches*: copyright 1966–1968 Canal+ Image UK Ltd. *The Woman In Black* copyright 2011 Squid Distribution LLC, The British Film Institute. *Let Me In* copyright 2010 Hammer Let Me In Productions LLC.
Hammer Glamour © 2019 Graham Humphreys Ltd
Yield Up The Mystery Tour © 2018 Vincent Price Legacy UK
The Vincent Price Legacy Tour © 2016 Vincent Price Legacy UK
An Evening With Martine Beswick © 2019 Graham Humphreys Ltd / Misty Moon
Oakley Court Film Fair © 2019 Graham Humphreys Ltd
Vulcan 7 © 2018 (Commissioned by Bob King Creative)
Manhunter/Trick 'r Treat © 2013 Graham Humphreys Ltd
Jason: Kane Hodder © 2015 Graham Humphreys Ltd
Satanic Mojo AD72 © 2015 Graham Humphreys Ltd
An Evening With Ian Ogilvy © 2018 Graham Humphreys Ltd. / Misty Moon
An Intimate Evening With Linzi Drew © 2019 Graham Humphreys Ltd. / Misty Moon
The Beyond Tour © 2017 Graham Humphreys Ltd/Fabio Frizzi
Zombie Apocalypse Tour © 2016 Graham Humphreys Ltd/Beat Records
Weekend Of The Dead 2017 © 2017 Graham Humphreys Ltd
Weekend Of The Dead 2018 © 2018 Graham Humphreys Ltd
The Return Of The Living Dead/Re-Animator © 2013 Cult Screenings

PRIVATE COMMISSIONS

An American Werewolf In London © 2017
Poltergeist © 2016
The Evil Dead © Silver Bow Gallery 2014
Evil Dead II © Silver Bow Gallery 2014
Army Of Darkness © 2016 Silver Bow Gallery
In The Mouth Of Madness © 2019 MCMXCIV New Line Productions
Soulmate © 2015 Axelle Carolyn
What We Do In The Shadows © 2015 Silver Bow Gallery
The Thing © 1982 Universal City Studios Inc.
Night Of The Creeps © 2016
Thriller: A Cruel Picture © 2014
Dracula/Van Helsing © 2012 De Montfort University
Halloween © 2016

RECORD COVERS

Vault Of Horror: The Italian Collection: Vol 1 © 2017 Demon Music Group Ltd.
Vault Of Horror: The Italian Collection: Vol 2 © 2019 Demon Music Group Ltd.
The Zero Boys © 2017 Arrow Films
Caltiki © 2017 Arrow Films
The Evil Dead re-imagined © 2018 Mondo
Gates Of Hell Trilogy © 2018 Beat Records (Italy)
The Devil Rides Out © 2012 Death Waltz Records
The League Of Gentlemen – Special Stuff 4 x LPs © 2018 Demon Music Group Ltd.
The League Of Gentlemen – Live Again! © 2019 Demon Music Group Ltd.
Erik The Conqueror © 2017 Arrow Film
Autopsy © 2017 Arrow Films
Untouchable Glory – Gama Bomb © 2015 AFM Records
Other Worlds Other Monsters © 2017 Andrew Liles
Ticket To Rock – Daxx Roxanne © 2017 Justice Brothers Records
Tales From Thee Creepfreaks © 2018 Greystone Records
Frizzi 2 Fulci – Undead In Austin © 2016 Beat Records
The Beast In Space © 2017 Mondo
The Conqueror Worm © 2019 The Core, Vincent Price Legacy UK
Pop the Bubble – Dolls © 2018 Mondo

In Search Of Darkness (2019). I was approached by the producer of this documentary on the horror films of the 1980s – an era cited as a "golden age" within the genre, in part propelled by the growth of home entertainment on VHS – to provide an image for the project. It would have two functions: to promote the project on social media and to provide an "award" level printed poster for a crowd-funded campaign. My work during the 1980s is referenced in the image, but I also worked from a wish-list of key films provided by the producer. Additionally, I was asked to participate in an interview about my work for inclusion in the documentary. © 2018 Red Sky Vision Ltd.

"The enduring legacy of my father, Boris Karloff, is, in great measure, thanks to the loyalty and passion of his fans; not least among them being the creative ones, like Graham Humphreys. Mr Humphreys' beautiful Karloff art pays such loving tribute, both to my father and his work, and allows fans the world over to continue to enjoy the beauty of his work and the memories that my father's legacy brings back to us all. Thank you, Graham."

SARA KARLOFF

"The genre of horror, because of its examination of things dark and strange, demands a certain theatricality in approach. And capturing the spirit and tone of a horror film in a single image such as a poster or DVD cover is especially challenging. Time and again, Graham's masterful artwork meets and exceeds that challenge. His illustrations are consistently vivid and energetic and always convey an uncanny sense of motion and emotion. Graham Humphreys is at the pinnacle of his craft, and I am so honoured to have been the subject of a number of his stellar works."

JEFFREY COMBS

"The painted horror poster has been an essential tool of B-movie hucksters for over a century, only very recently being replaced by the literalness of the photographic image. But the most memorable horror and fantasy film posters are the illustrated collages of faces and essential moments from the films, or the bold single iconic image, often rendered in garish un-natural colours, adorned with vibrant hand-hewn lettering. These are the posters we remember. Graham Humphreys' deft touch and loose painterly textures bring modernity and panache to this beloved tradition, providing a new generation with haunting images to keep them aghast and awake way past midnight."

LARRY FESSENDEN